HELP!!! THERE'S AN ELEPHANT IN MY HOUSE!

By Onur Tukel

Pitchstone Publishing
Durham, North Carolina

Pitchstone Publishing
Durham, North Carolina
www.pitchstonepublishing.com

Printed in the USA

10 9 8 7 6 5 4 3 2 1

Book design and cover by Onur Tukel

Names: Tukel, Onur, author.
Title: Help!!! there's an elephant in my house! / by Onur Tukel.
Description: Durham, North Carolina : Pitchstone Publishing, 2019.
Identifiers: LCCN 2018049181| ISBN 9781634311823 (hardcover : alk. paper) |
 ISBN 9781634311830 (pbk. : alk. paper) | ISBN 9781634311861 (mobi)
Subjects: LCSH: Political poetry, American. | Humorous poetry, American. |
 Republican Party (U.S. : 1854-)—Humor.
Classification: LCC PS3620.U525 H45 2019 | DDC 811/.6—dc23
LC record available at https://lccn.loc.gov/2018049181

HELP!!! THERE'S AN ELEPHANT IN MY HOUSE!

By Onur Tukel

There's an elephant in my house!
Oh dear! Oh dear!
He's destroying my life!
I don't want him here!

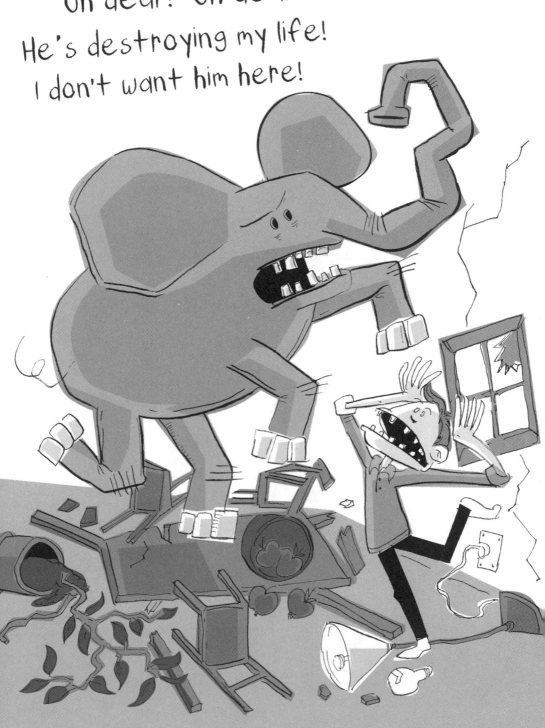

He's cracking the floors!
He's splitting the walls!
He's big and he's mean!
I don't like him at all!

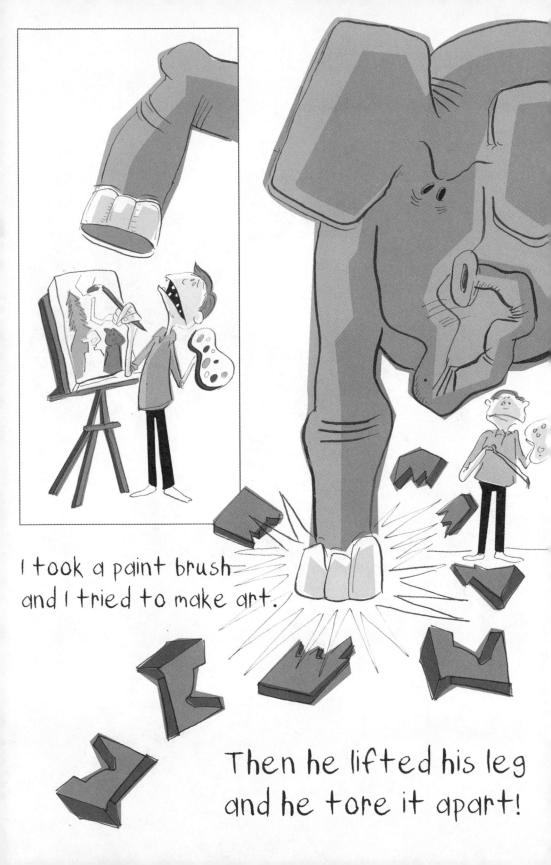

I took a paint brush
and I tried to make art.

Then he lifted his leg
and he tore it apart!

I have a bookshelf
 filled with books of all kinds!

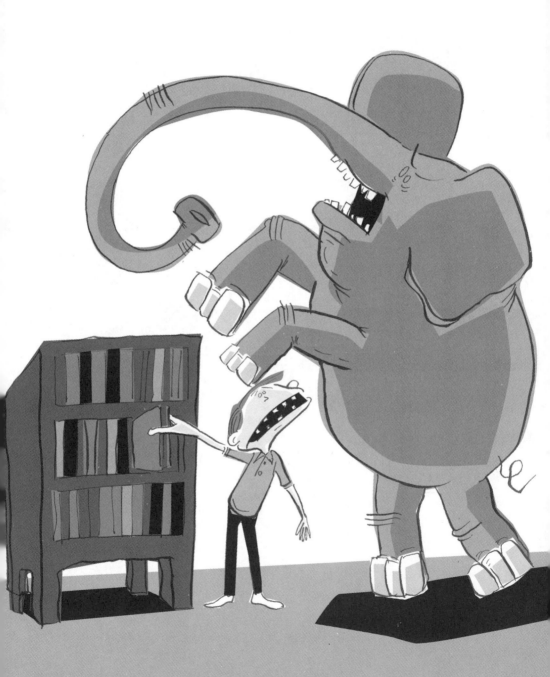

But the elephant crushed
all their covers and spines!

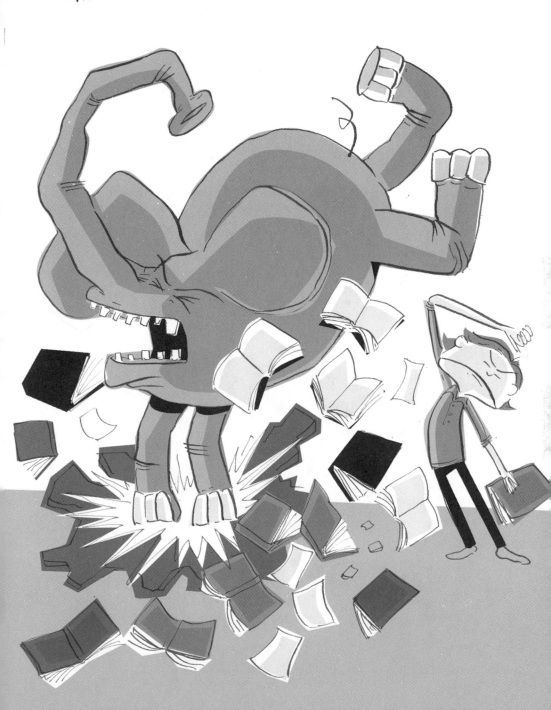

When he stomped through my garden,
I yelled out, "Please stop!"
This beast doesn't care
about the earth or the crops!

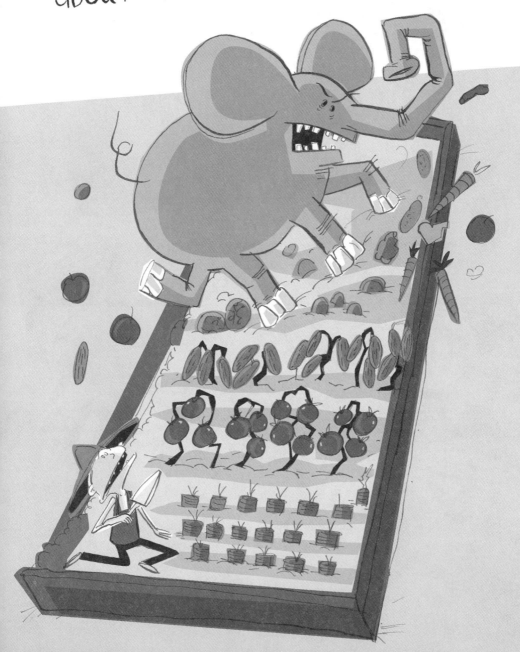

He yanked up the trees
growing in the front yard!

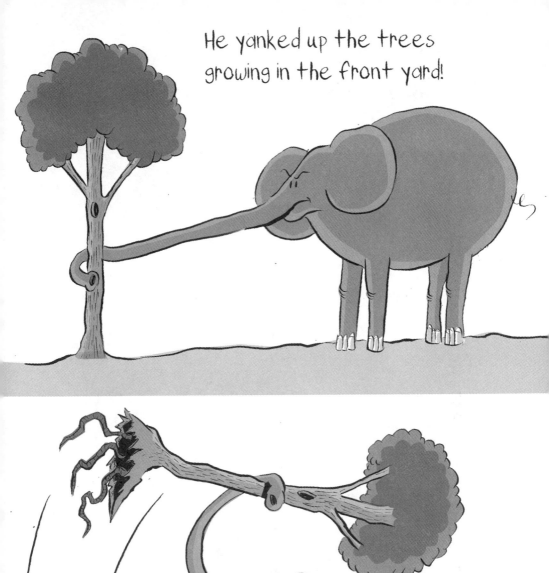

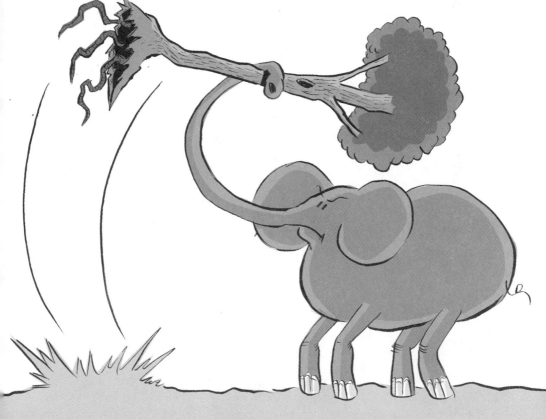

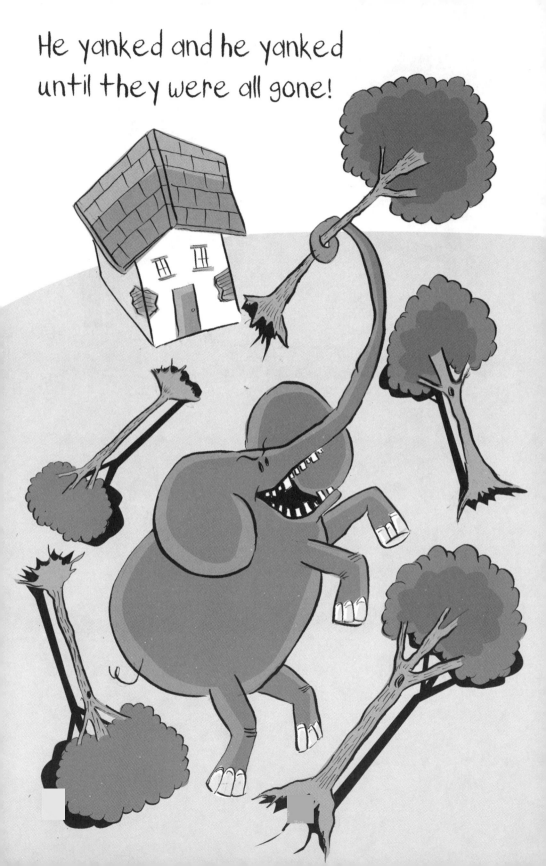

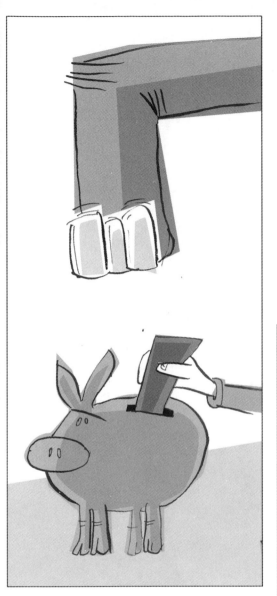

Then he lifted
his leg
and he stomped
on my bank.

Why would you do something careless like that?

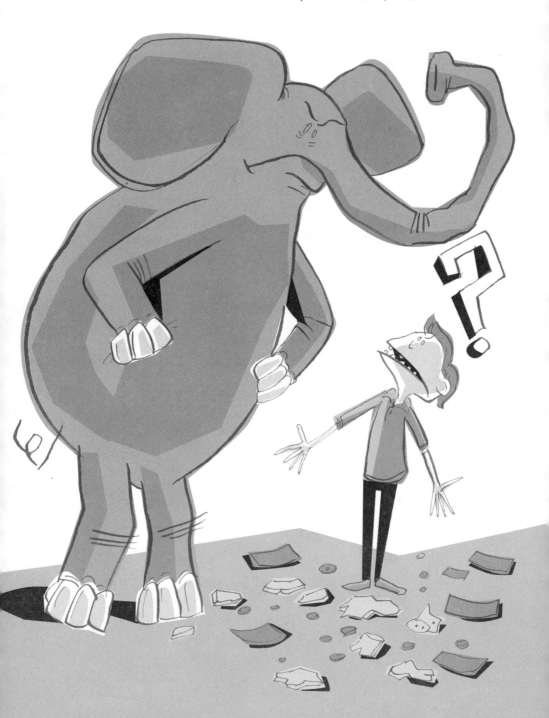

When my friends come over
they're scared and astonished.
We need to act quick
before the house is demolished.

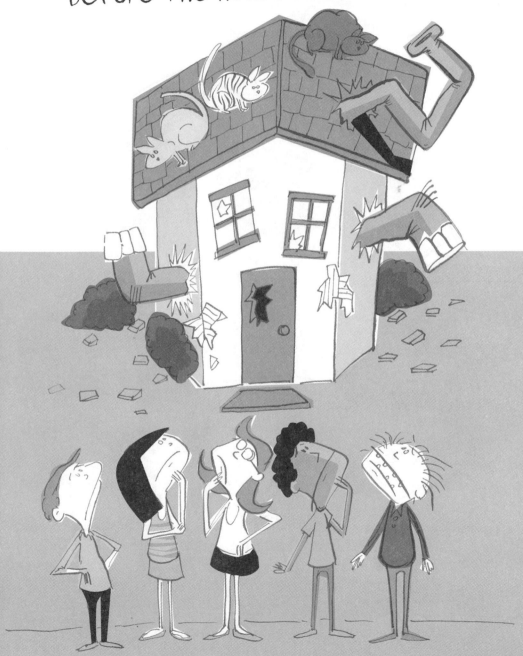

The elephant doesn't want
my friend Miguel to enter.

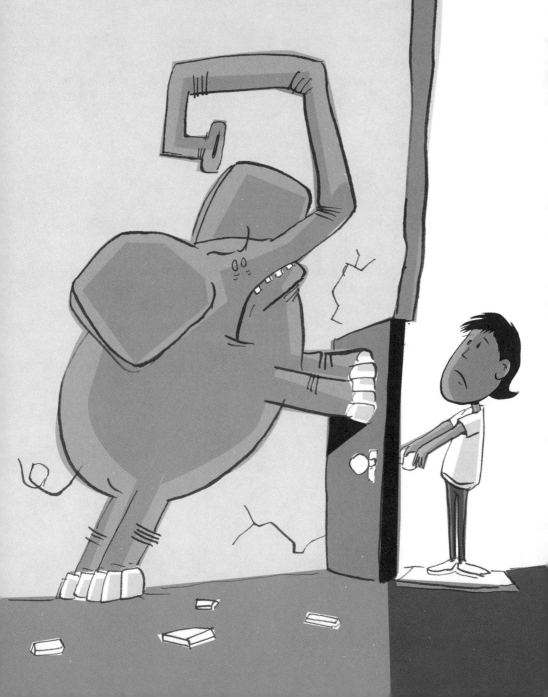

So he builds a large fence around the perimeter!

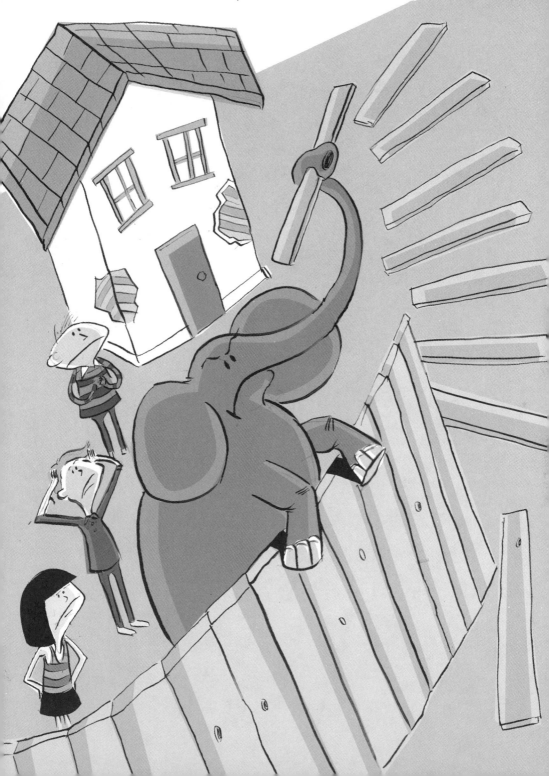

It stretched up so high
we could not see above it.

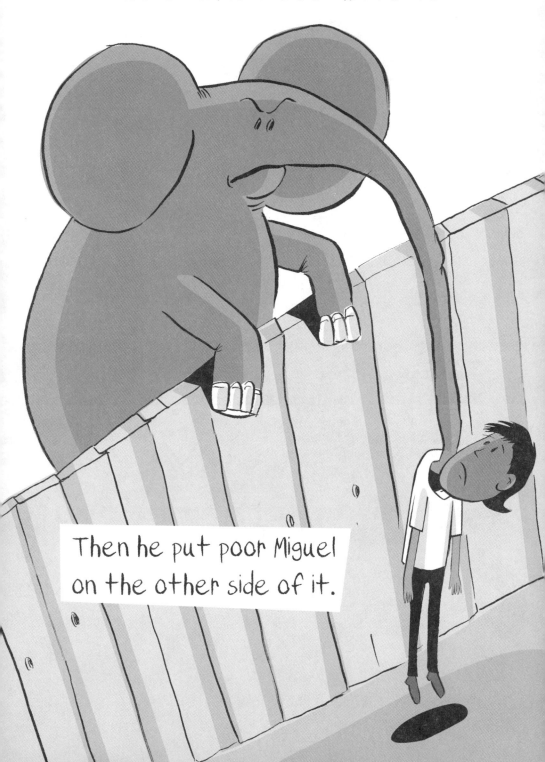

Then he put poor Miguel
on the other side of it.

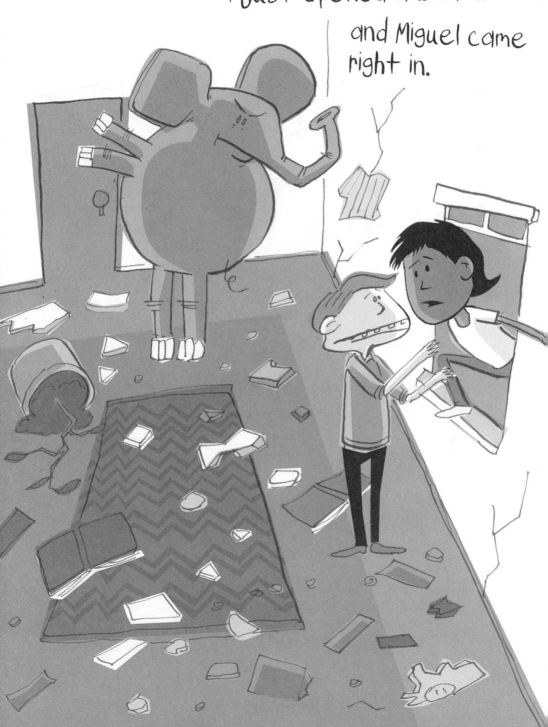

When Joan cut her finger
on a sharp wooden peg,
the elephant charged her
an arm and a leg.

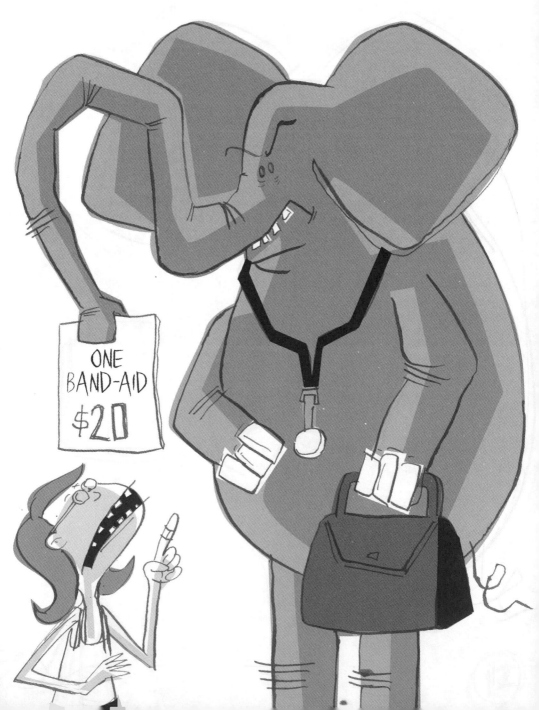

Our friend Muhammad lives in the house next door.

The elephant crushed him and stole his motor oil.

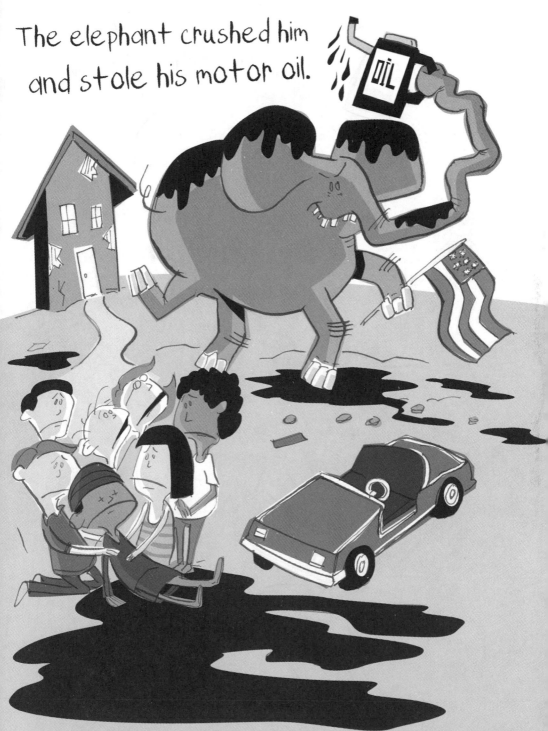

Then he looked for something
else nasty to do.

So he yanked the solar panels
right off of the roof!

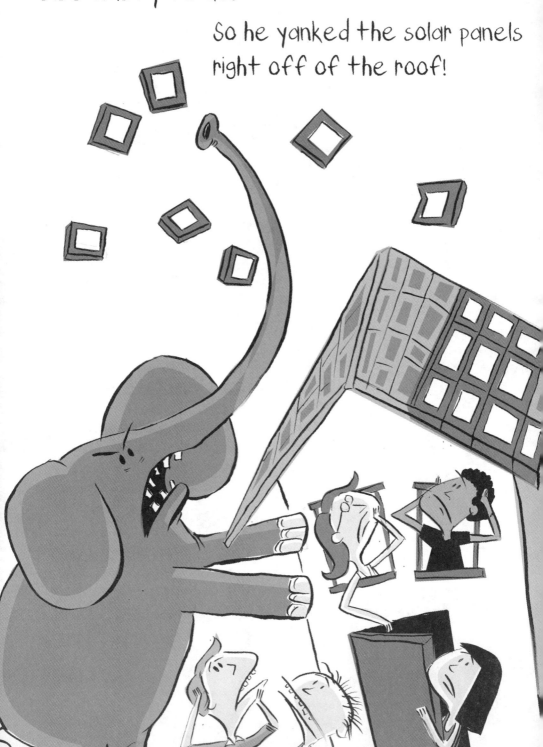

Then he threw away all the recycling bins.

And he caged up my chickens and free-roaming hens!

The elephant screams,
"Stay in your places!!!"

Then he tries to separate
us all by our races.

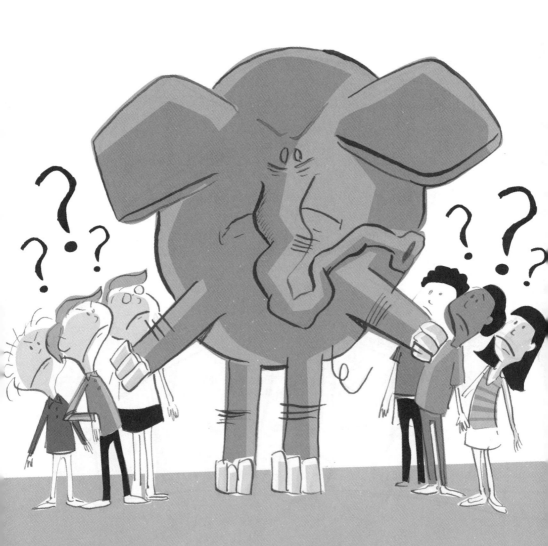

When we play Monopoly,
we play by the rules!
But he throws them out and says,
"Rules are for fools!"

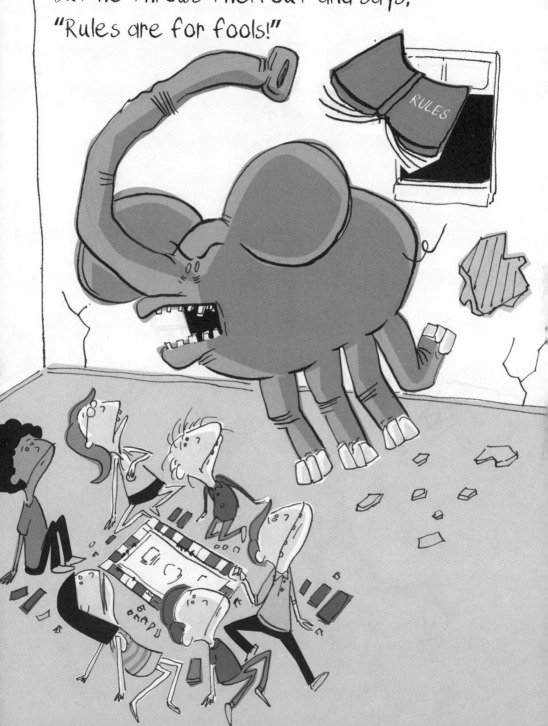

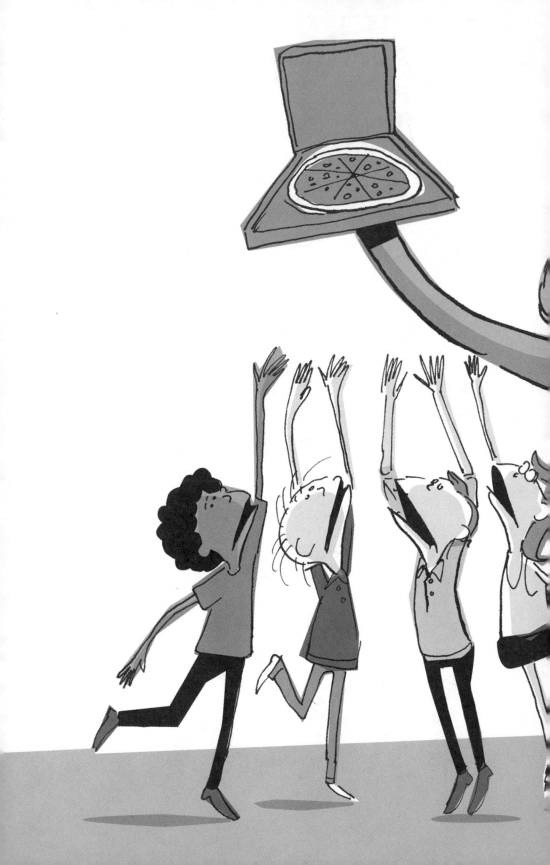

When we ordered a pizza,
the elephant seized it!
What he did next,
you just won't believe it.

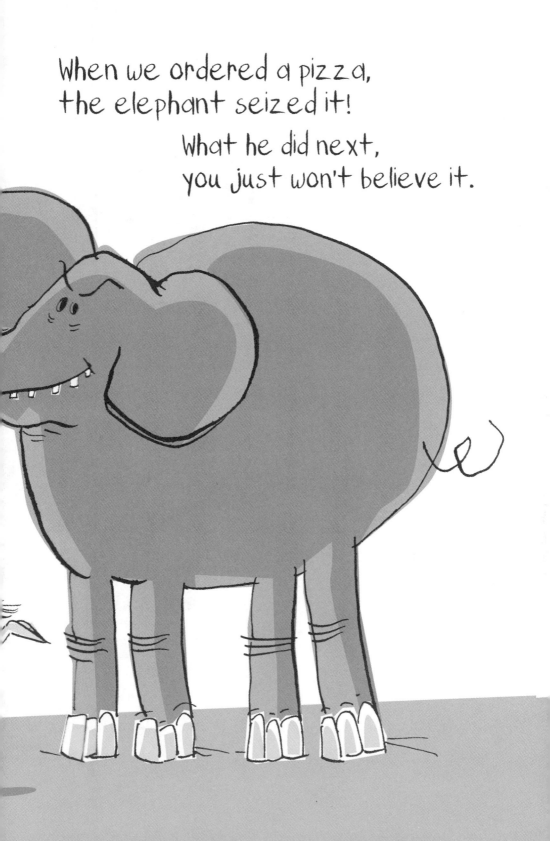

He gave it to the fat
cats perched from
above.

All we got
were the
trickling crumbs.

When it was playtime, we ran for the toys.

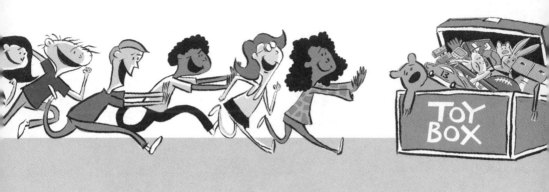

But the elephant didn't allow us a choice.

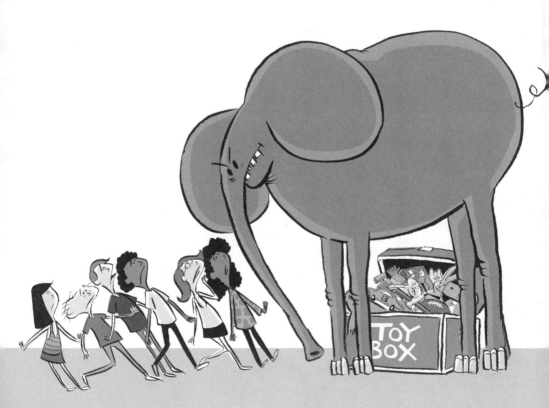

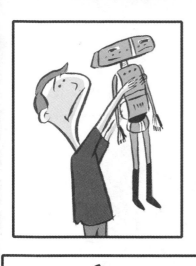

He gave Phil a robot.

He gave Ron a train.

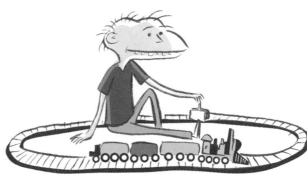

He let Andy play with a remote-controlled plane.

He gave all the girls one baby doll each.

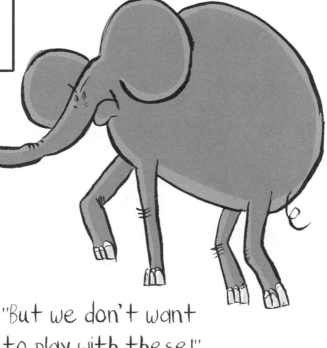

"But we don't want to play with these!"

"This baby's all mangled!"

"This one doesn't have legs!"

"I'd rather play with a
race car instead."

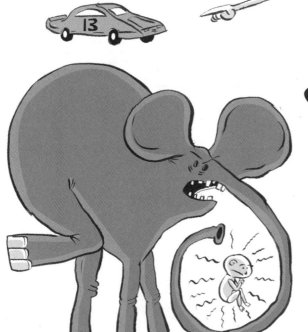

"NO!"

the elephant roars.
"That's strictly verboten.
I don't care if your baby
is disabled or broken."

"You'll keep it and love it,
 or you will be punished."
These words made the
 girls all sick to their stomachs!

"But we should decide!"
They all yelled in a rage.
"Shut up," the beast roars!
"Your decision's been made!"

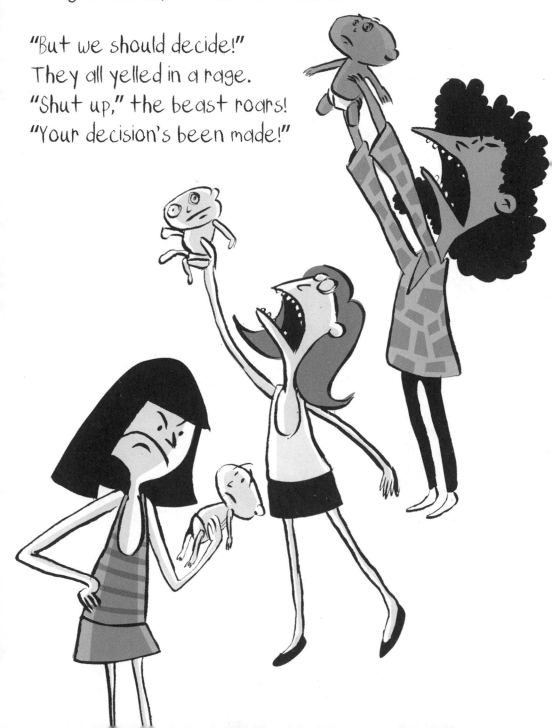

When we tried to have water that was clean and drinkable,

the elephant did something quite unthinkable.

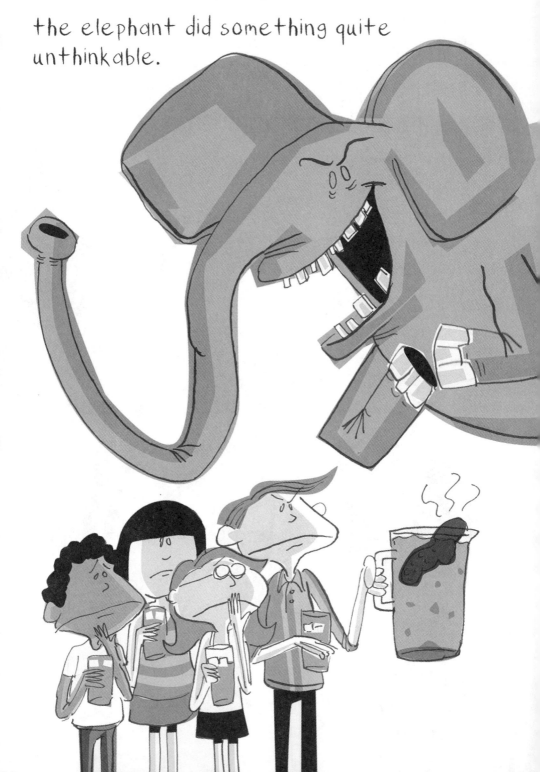

Then we hear a loud sound,
like a big sonic boom!

We all almost choke from the
gas in the room!

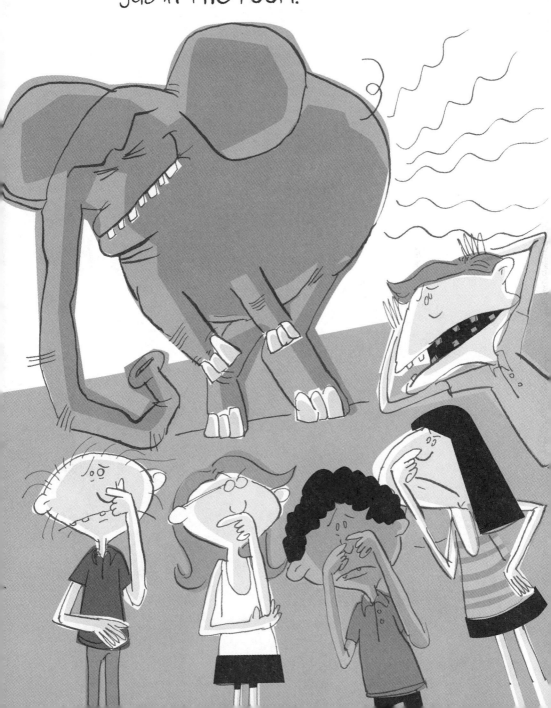

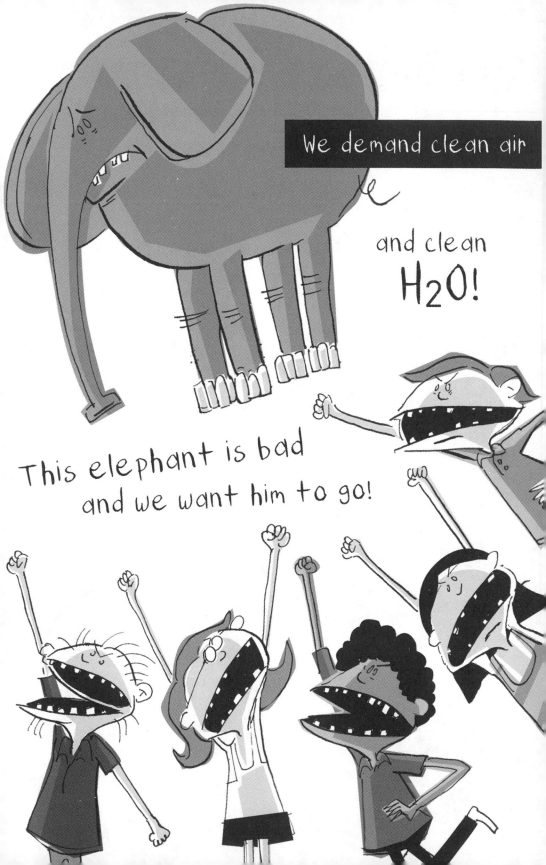

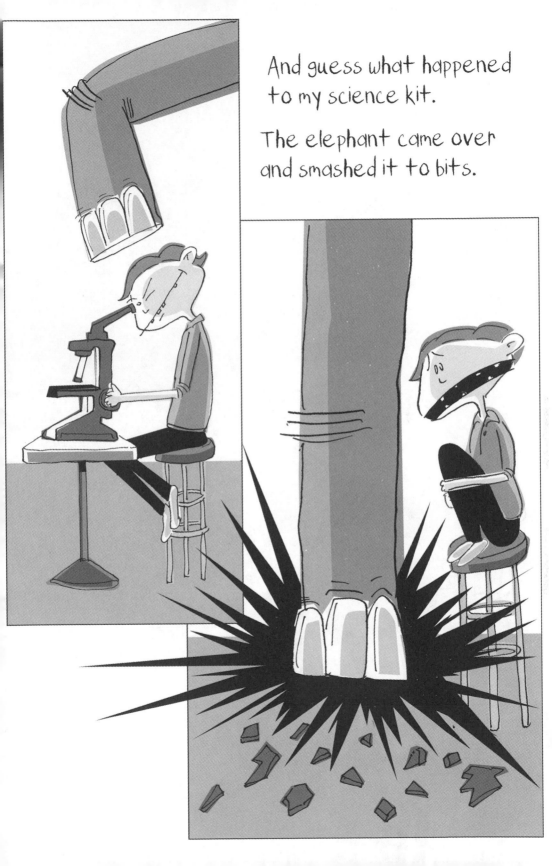

And guess what happened to my science kit.

The elephant came over and smashed it to bits.

"Science is a waste of time," the elephant admits.

"Why not play with this cool magic kit?"

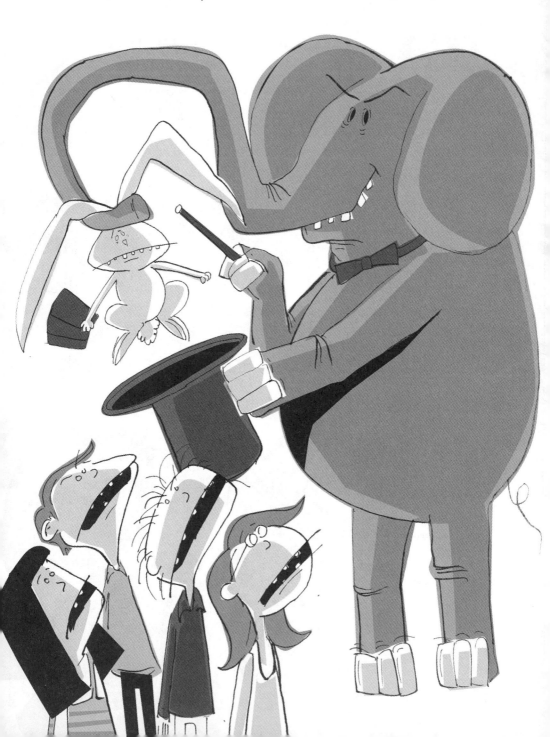

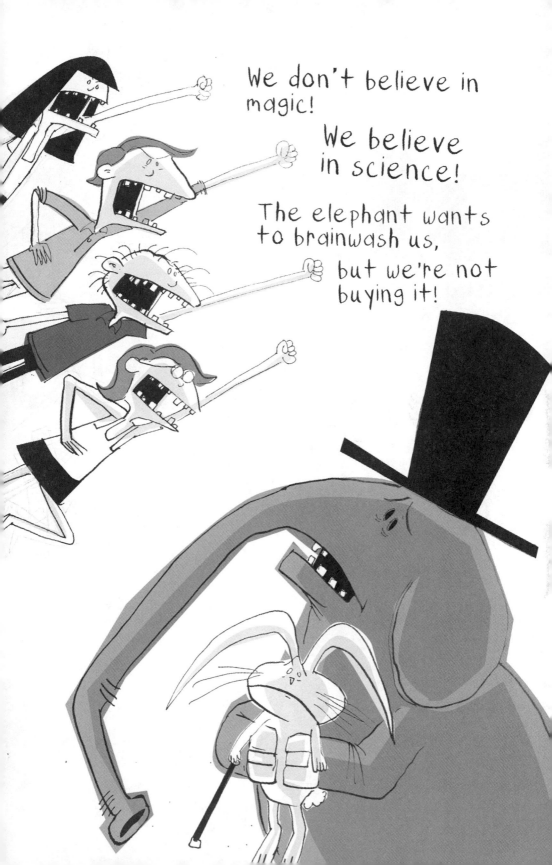

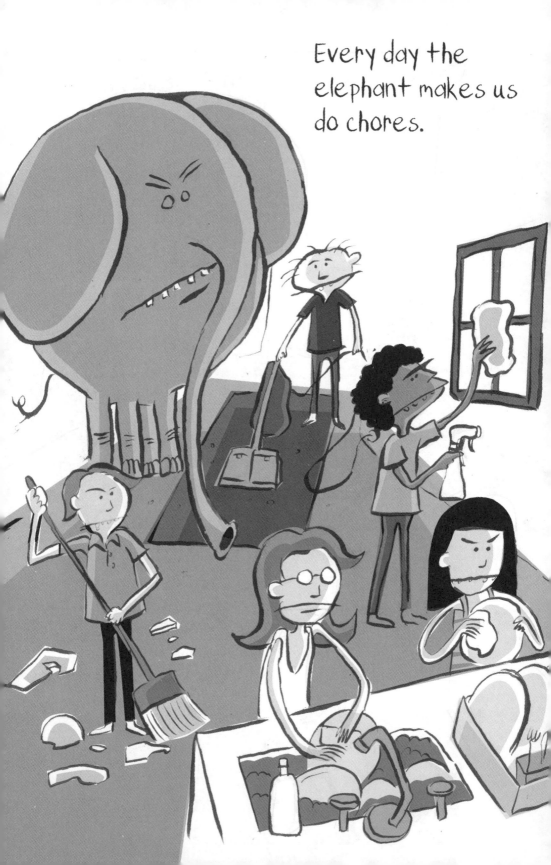

Every day the elephant makes us do chores.

But he always pays the girls
way LESS than the boys!

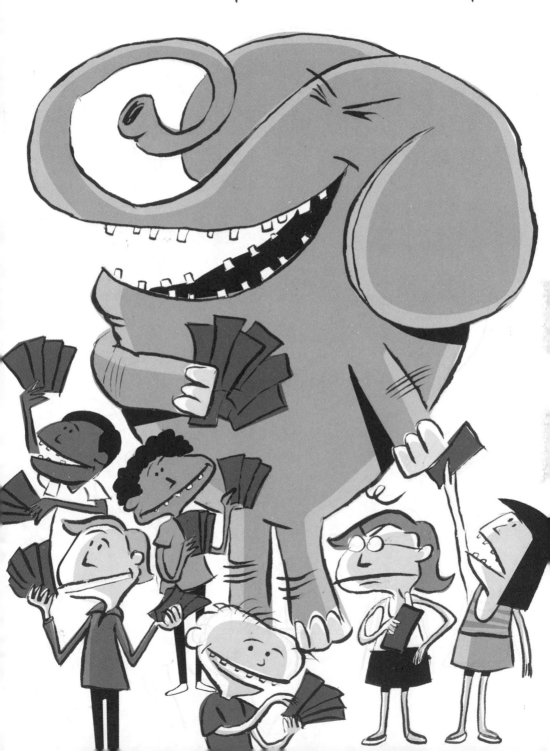

Then the elephant took back
a lot of our pay.

"Why did you do that?" we ask
with dismay!

He says, "This house is
in need of repair.
So like it or not,
you must pay your fair share."

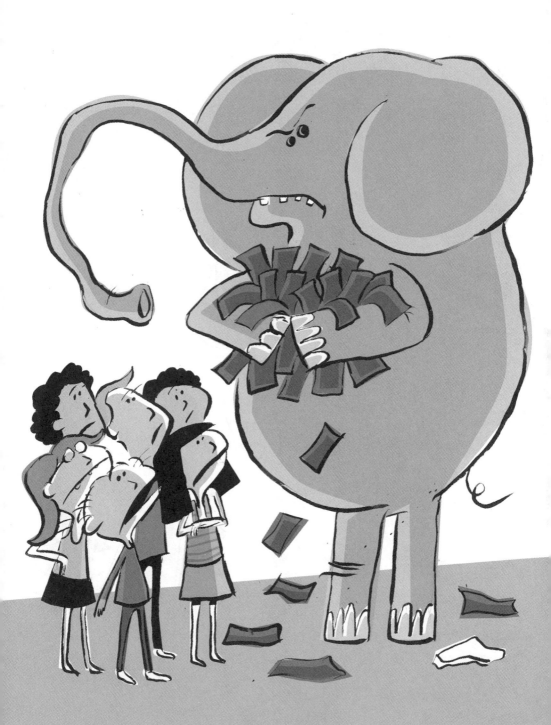

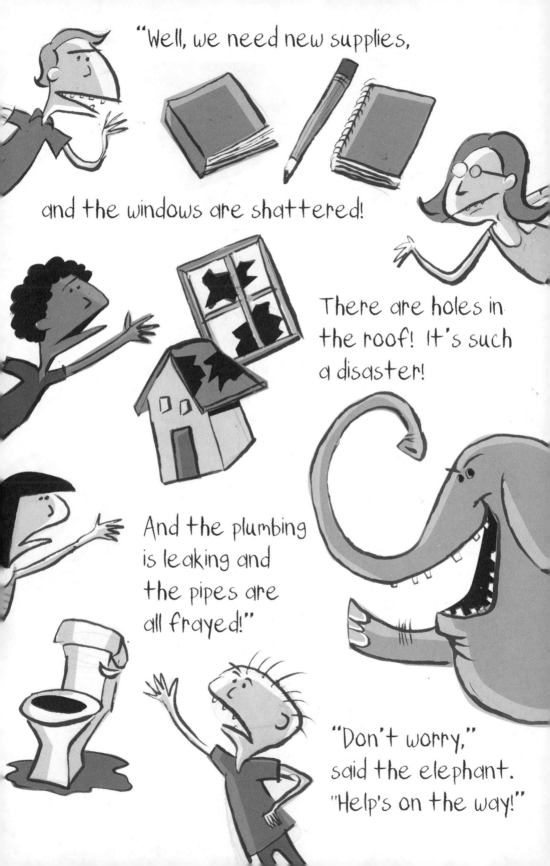

But the elephant doesn't fix
all the rust and corrosives.

He uses our funds to buy
lots of explosives.

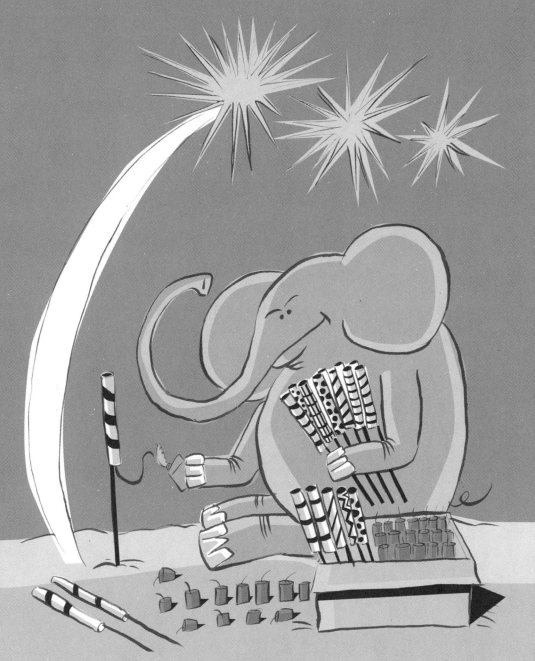

We have a rule in this house. "No sweets before supper!"

If we disobey it, we'll get into trouble.

When the elephant caught us,
he wasn't real friendly.

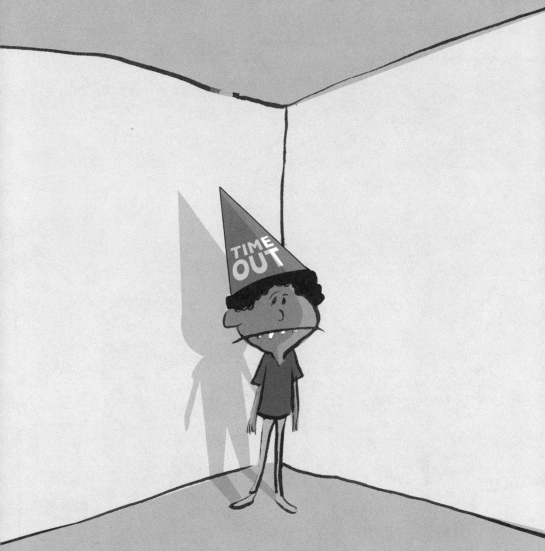

Yet the only person he punished
was our black friend Henry.

Our house has two bathrooms,
one for boys, one for girls.

But before you can pee,
he must check
something first.

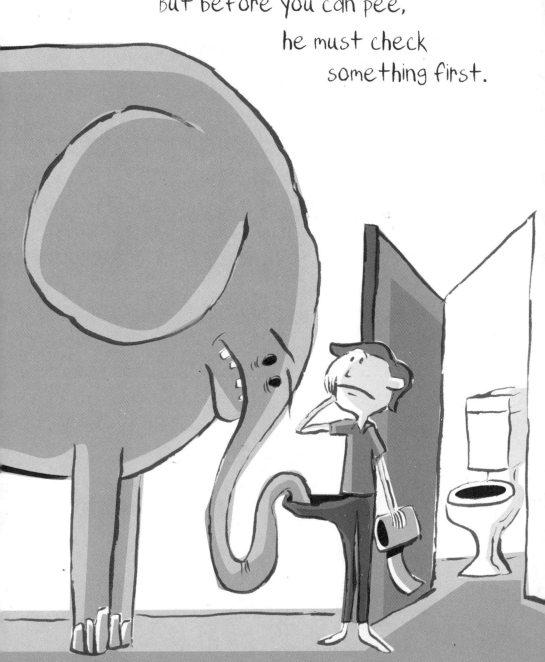

This elephant's so
LOUD!

This elephant's so
MEAN!

Yet, he's in all the
newspapers and on
every screen!

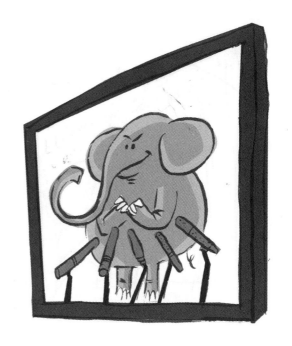

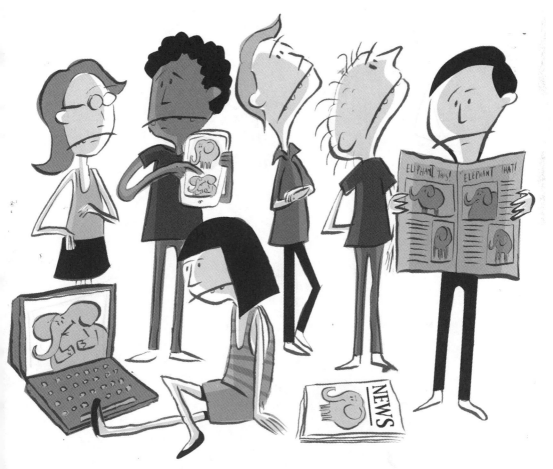

Everything he says
just seems to be wrong!

Is that the reason
his nose is so long?

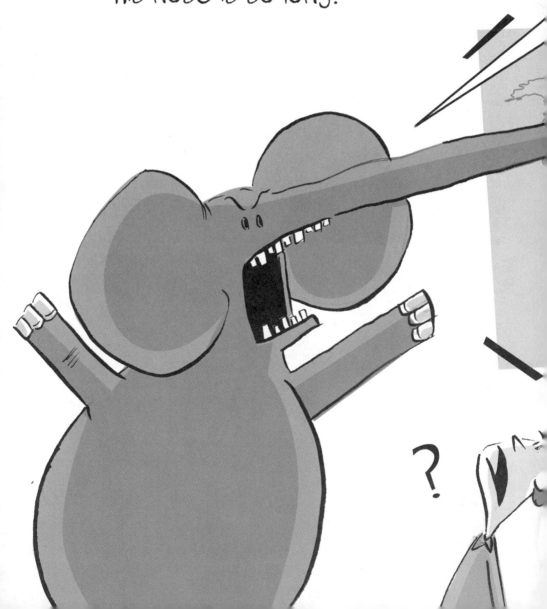

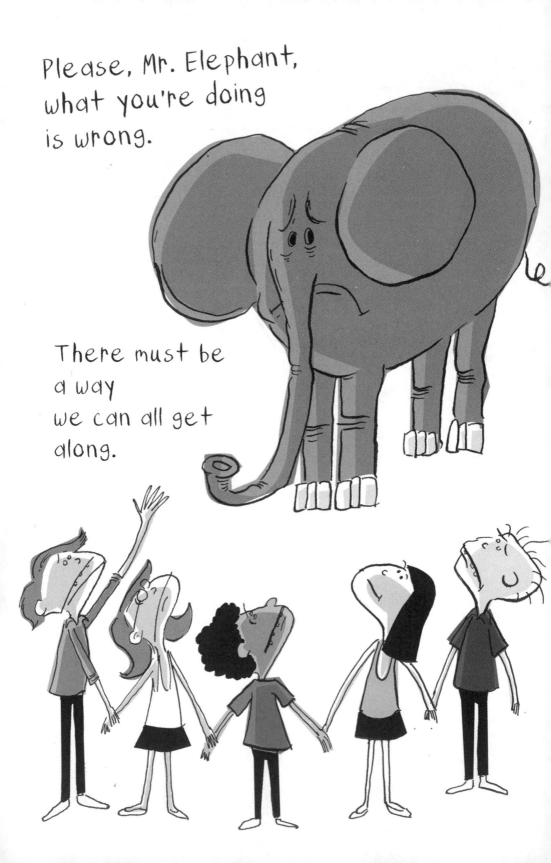

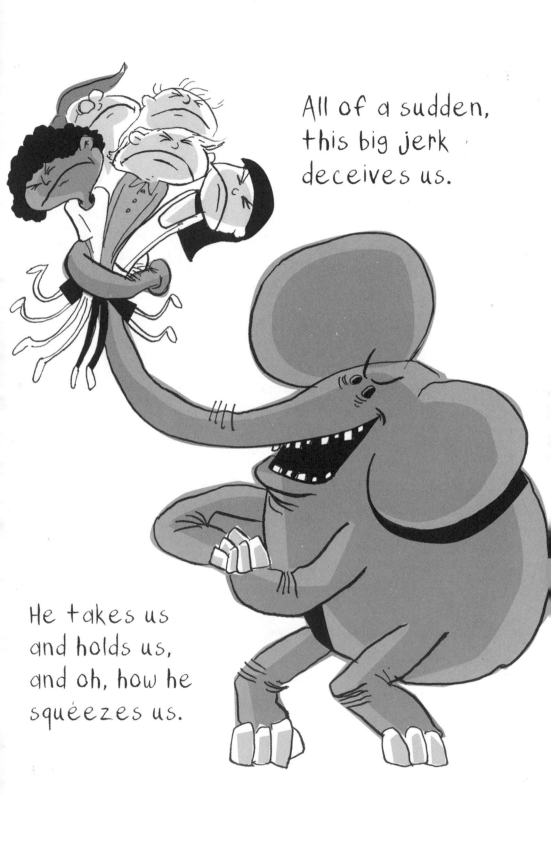

All of a sudden, this big jerk deceives us.

He takes us and holds us, and oh, how he squeezes us.

This elephant has to go!
He's just a big bully!

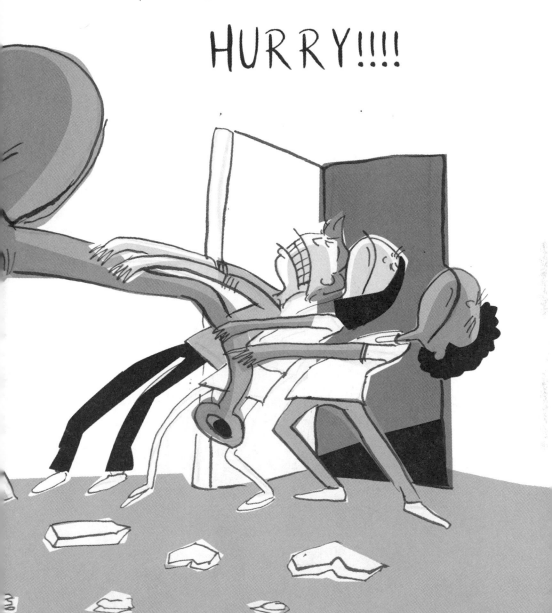

And then our friend Paul
 came out of the closet.

When the elephant saw him,
he pretty much lost it.

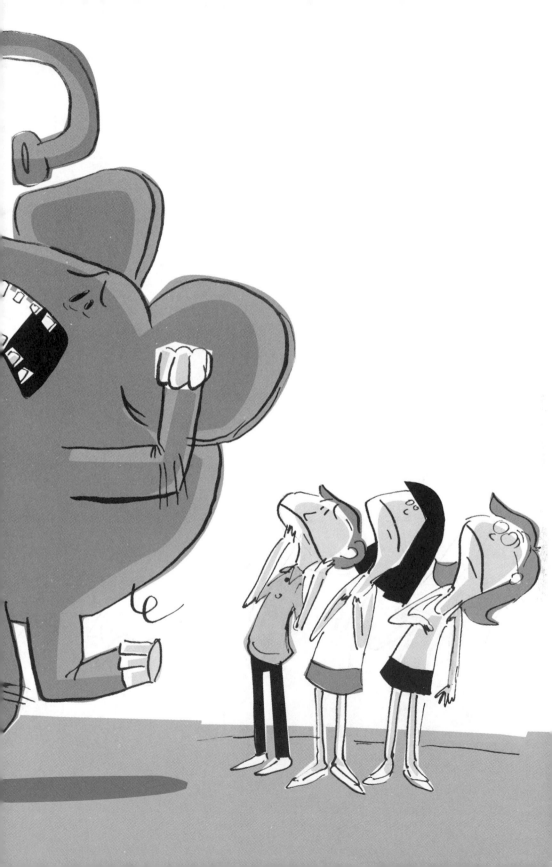

But wait, what's this?
 The elephant's scared of Paul.

Is it because he wears
nail polish and a pink
fluffy shawl?

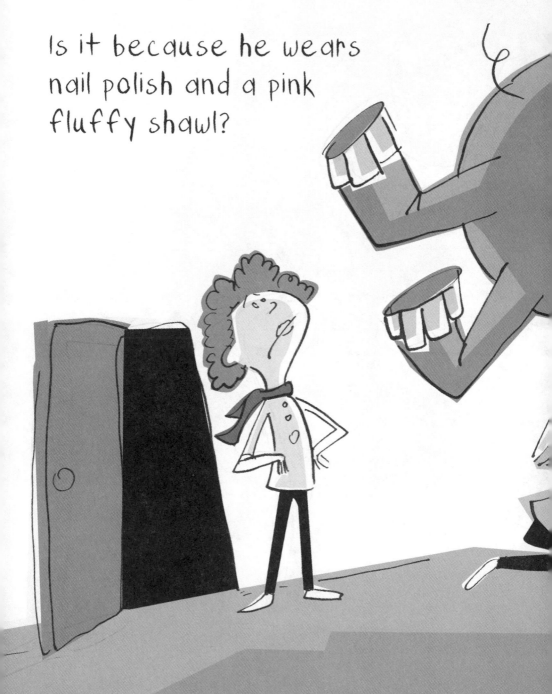

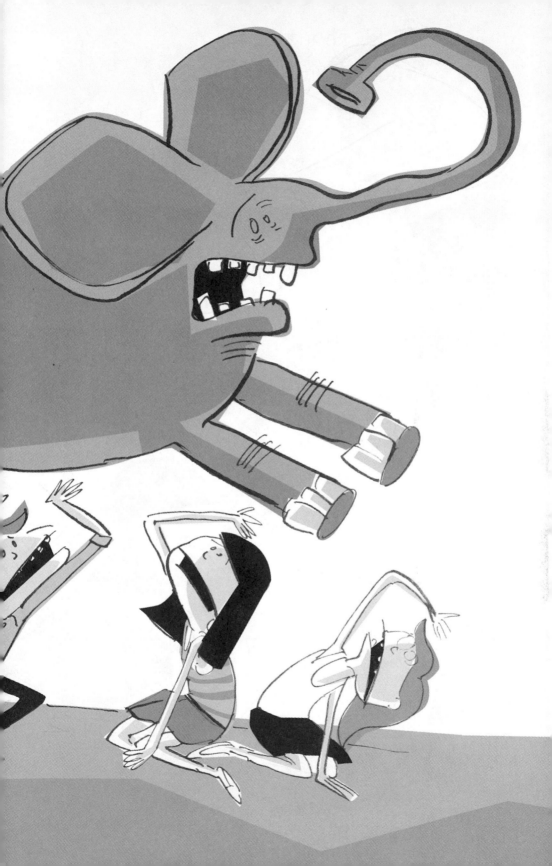

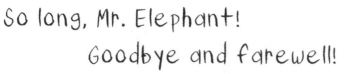

So long, Mr. Elephant!
 Goodbye and farewell!
 You've damaged our house,
 and you've made
 our lives hell!

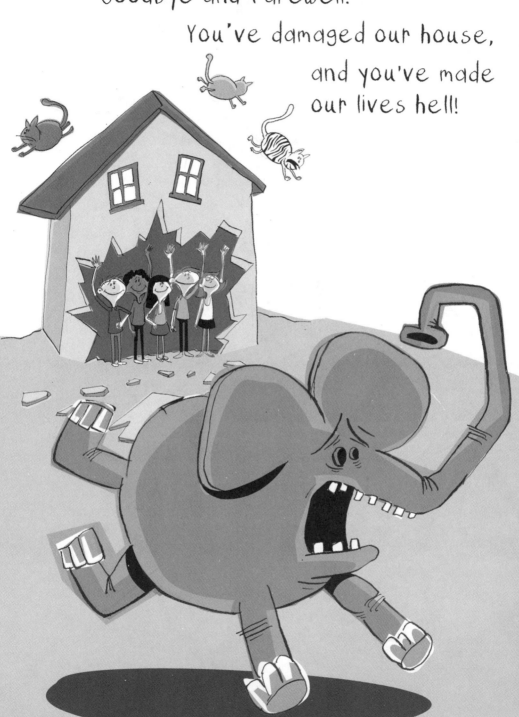

We'll fix all the pipes
and we'll tear down the fence.
And we'll go find Miguel
and we'll let him back in.

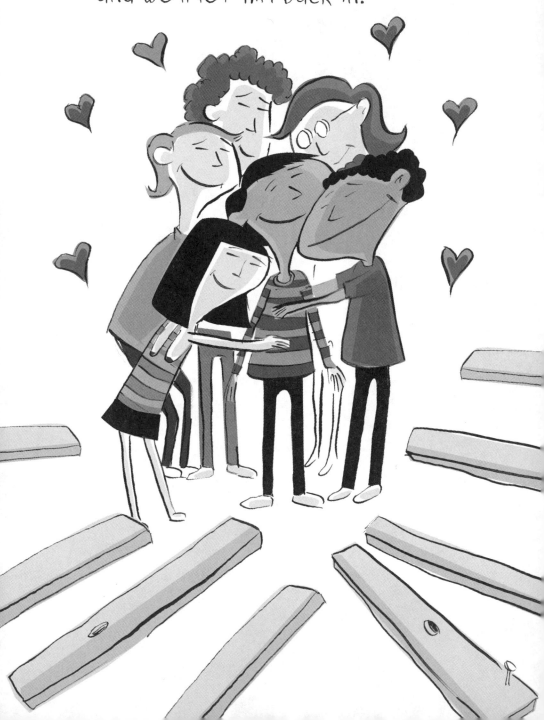

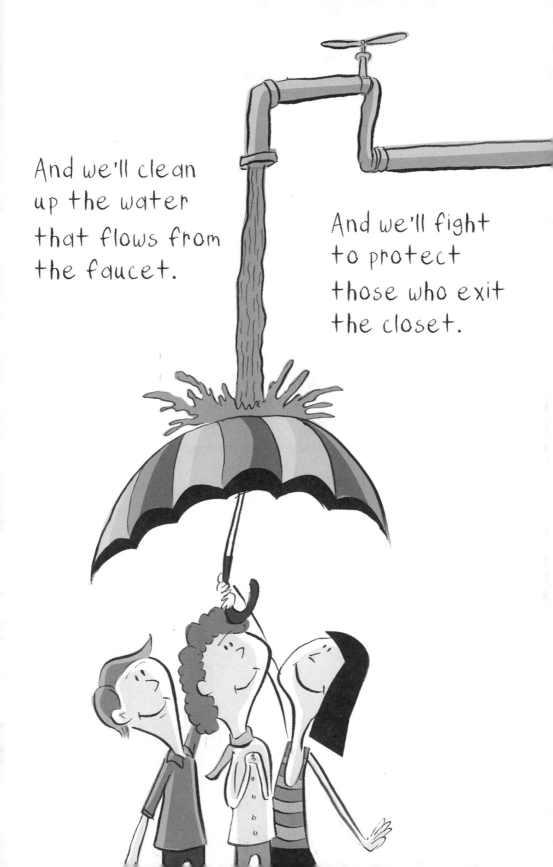

And we'll clean up the water that flows from the faucet.

And we'll fight to protect those who exit the closet.

We'll distribute first aid
to the injured and sick,

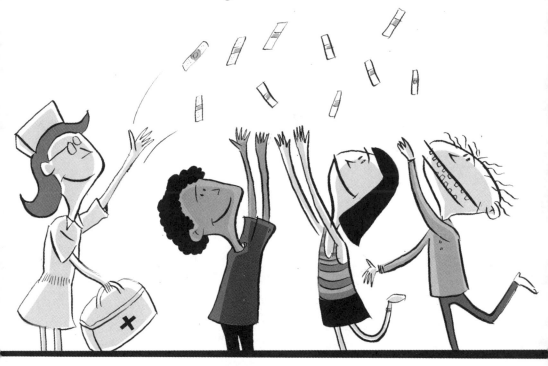

and we'll perform math and science
like a cool magic trick.

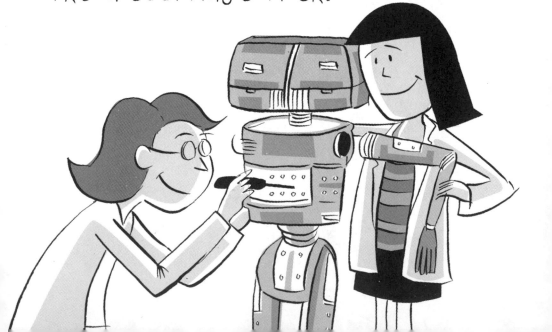

And we'll let all the girls
return unwanted toys,

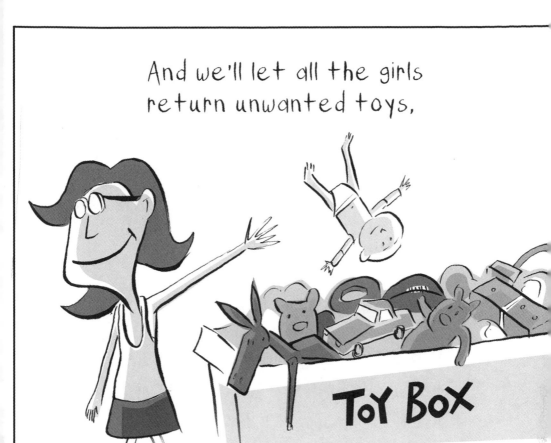

and we'll make sure they
get paid the same as the boys.

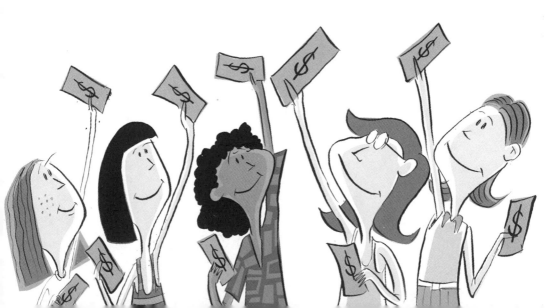

And we'll keep reading books,
and we'll keep making art,
and we'll never again
let you split us apart.

And we'll all come together,
and we'll fight against wrong,
and we'll hold our heads high,
and we'll break into song!

And we'll clean off the flag
that you showed no respect.
And we'll fix up the house
that you damaged and wrecked.

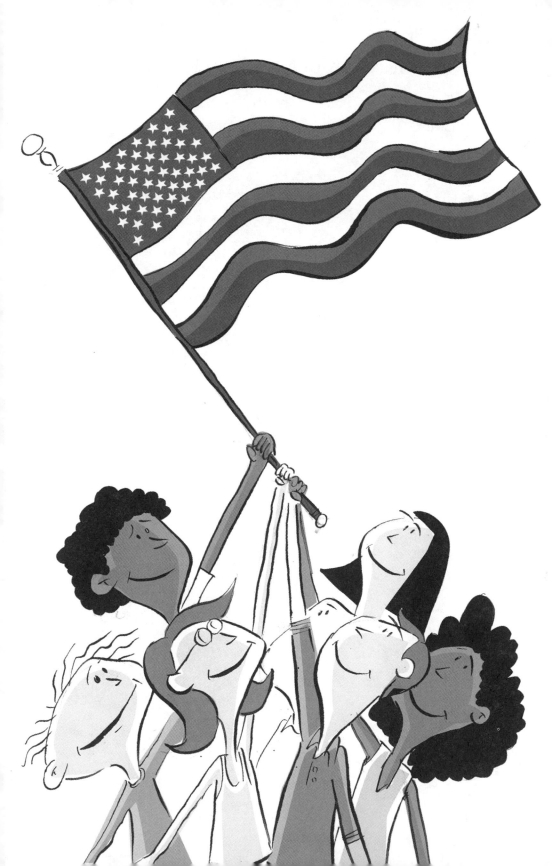

Then we'll fix all the houses
that are here on our street!
And we'll share our ideas,
and we won't be discreet.

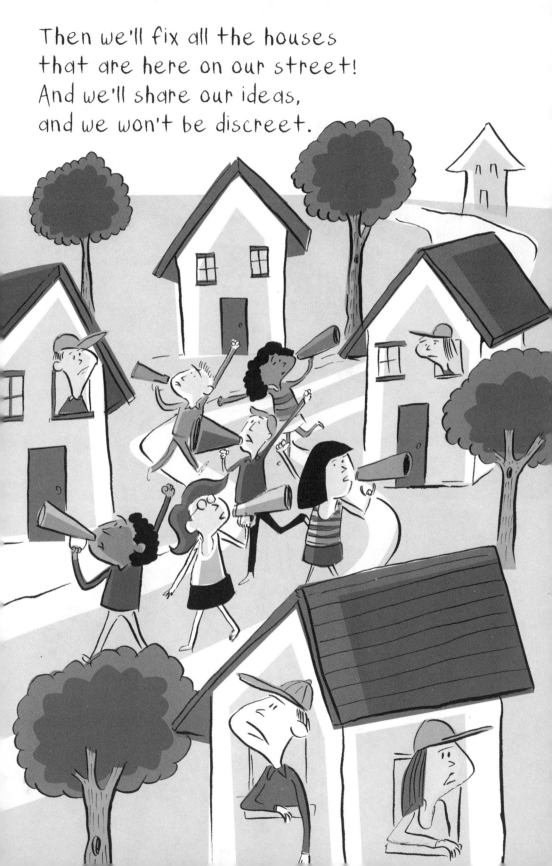

And we'll storm the computers
and all of the phones,
then we'll find a strong beast
of our very own.

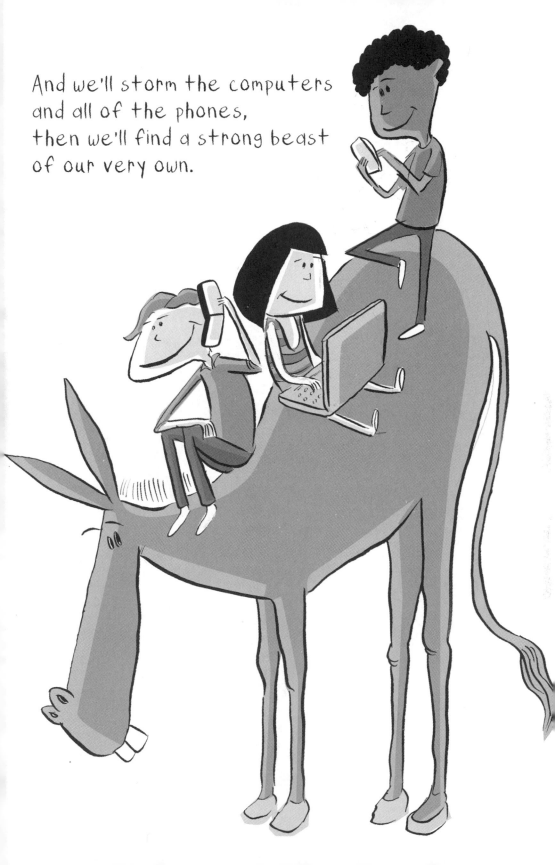

And he'll be a symbol
of the young and the new,
and we'll use him to spread
all our positive views.

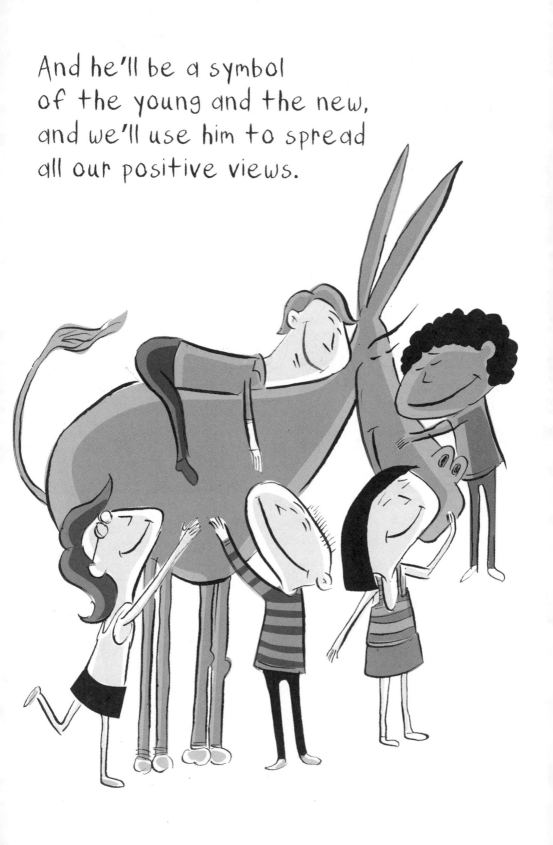

He'll be noble and strong
and will solve all our problems.
Our beast will run wild,
and no one will stop him!

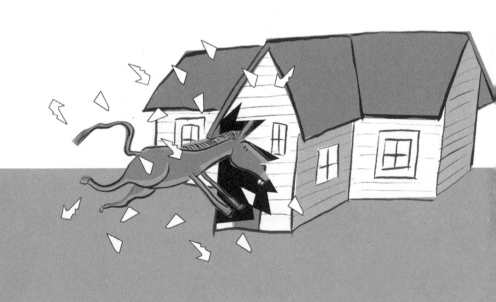

There's a donkey in my house!
Oh, my goodness! Oh dear!
Let's get him out quick.
I don't want this beast here!!!

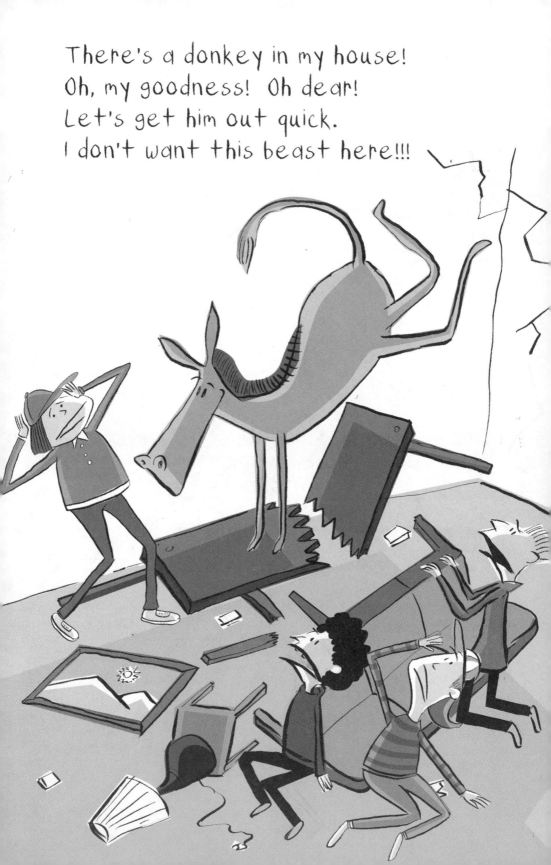

Onur Tukel is a writer, artist, and filmmaker.

He's written and directed several feature films, including *Summer of Blood, Applesauce,* and *Catfight,* which premiered at the 2016 Toronto Film Festival.

He has written and illustrated two previous children's books, *Little Friends* and *Rainstack!*

You can see his work at simiannation.com.